Constable Country

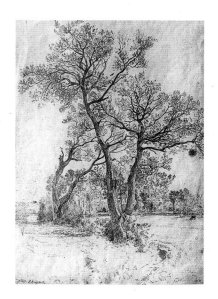

National
Trust

'Landscape is my mistress ...'

'– tis to her I look for fame – and all that the warmth of the imagination renders dear to Man.'

John Constable, 1812

The beautiful landscape of Constable Country captivates thousands of visitors every year and it is easy to see why the artist John Constable was inspired to paint some of England's best-loved pictures.

John Constable was the fourth child of six born to Golding Constable and Ann Watts on 11 June 1776 at East Bergholt, Suffolk. His father owned Flatford and Dedham water mills, and a windmill in East Bergholt. He was a prosperous corn merchant whose business activities also included a shipping operation based at Mistley on the Stour Estuary. John grew up in middle-class comfort at East Bergholt House, a substantial home built by his father in the centre of the village.

After schooling at Lavenham and Dedham, John Constable began training as a miller at his father's windmill in 1793. His spare time was spent painting and drawing with his friend and neighbour, John Dunthorne, the village plumber and glazier. By the age of 20, he had met several artists and art connoisseurs through Sir George Beaumont, whose mother lived in Dedham. An amateur painter and a patron and benefactor of Coleridge and Wordsworth, Sir George gave valuable advice and encouragement to Constable over the next 25 years.

It was not until March 1799, having won over his parents to the idea that he wanted to become a painter, that Constable entered the Royal Academy Schools in London. Spending holidays in East Bergholt most years until 1817, the scenes he chose to paint were pleasant and attractive but not of spectacular beauty. He chose them because they were familiar and were shaped by the profitable business of agriculture, a business to which he owed his well-being and security. These early memories of landscape sustained him for the rest of his life. At the age of 45 he wrote to his great friend John Fisher:

The sound of water escaping from Mill dams ... Willows, Old rotten Banks, slimy posts, & brickwork. I love such things.... As long as I do paint I shall never cease to paint such Places....

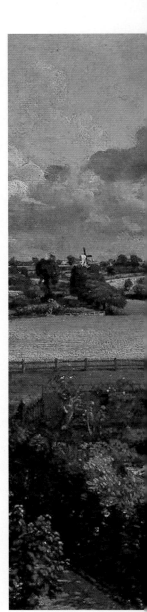

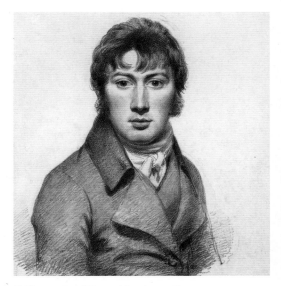

Self-portrait of Constable, about 1800 (National Portrait Gallery)

(*Opposite*) *Golding Constable's Kitchen Garden*, 1815 (Ipswich Museum)

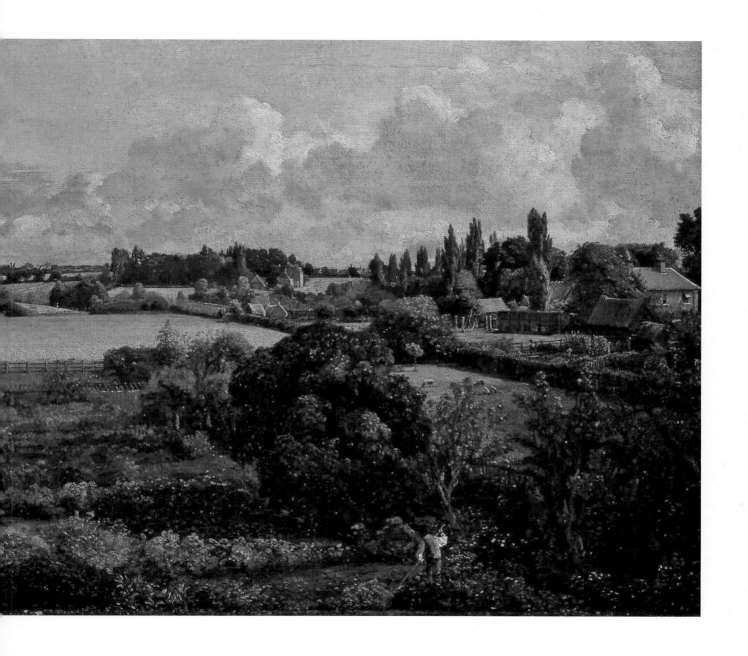

The Flatford Paintings

Following the map on the back cover you can discover Constable's famous views.

I *Boat-building near Flatford Mill, 1814–15*
(Victoria & Albert Museum, London)

Constable worked out of doors on this picture in the late summer of 1814. Uniquely, he also completed it on the spot, in order to capture the scene with a precision that his studio-bound contemporaries could not match. According to his engraver David Lucas, the artist knew it was time to finish painting each day by the smoke from Bridge Cottage chimney, which indicated that the occupant's supper was being prepared.

In the early 19th century, landscape paintings were usually generalised and idealised depictions of nature, based on the study of other pictures rather than actual scenes. They followed certain accepted conventions on how foliage should be painted, how the composition should be organised, and what colours should be used. Constable rejected all this, using nature directly as his inspiration. In consequence Constable's ability was not fully recognised for a long time and he was not elected a full Royal Academician until he was 53.

When the National Trust bought Bridge Cottage in 1985, the dry dock featured in this painting was full of rubbish. Initial excavations by the River Stour Trust revealed the remains of a barge, timber stocks and a brick floor. (The remains of the barge were measured, recorded and then re-buried behind Willy Lott's House.) A culvert was also found which drained the dock under the river and into the ditch beyond. This ditch is lower than the river, as the main river at Flatford is an artificially constructed channel to serve the Mill.

New dock gates were made, based on Constable's original drawings, and sections of the damaged dock floor were repaired with new bricks manufactured at the original Sudbury brick works, which is still in business. The dock is flooded periodically to keep down weed growth.

The dry dock today

4

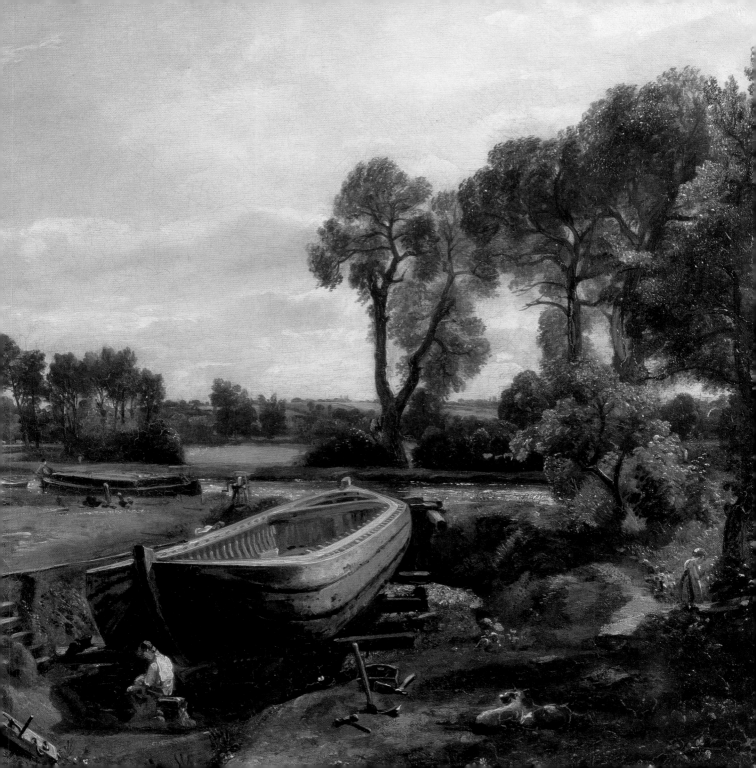

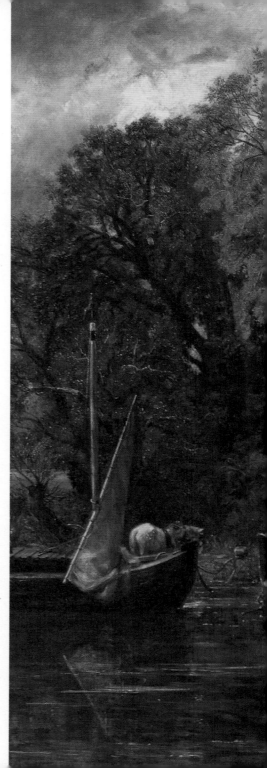

2 *View on the Stour near Dedham*, 1822
(detail) (Huntington Art Gallery, San Marino,
Los Angeles)

The bridge over the
Stour today

This painting depicts a barge being
manoeuvred into position to enter Flatford
Lock downstream, just beyond the left
picture edge. The sails were used on the
river to increase speed and to navigate
across the estuary from the river mouth to
Mistley. Here cargoes were transhipped to
sea-going vessels, like the one Constable's
father owned called the *Telegraph*.

In the foreground is the entrance to the
dry dock over which Constable has painted
a rake. This, and the opposing diagonal of
the river, give the composition its
underlying structure. Constable has also
used a large block of trees to give depth
contrasted with the flat background
landscape. An over-sized Dedham church
is visible in the distance as the focal point.
Pollarded willows obstruct this view today.

Constable is noted for his paintings of
the sky, of which this picture is a good
example. 'The Natural History of the
Skies', as he called it, was an abiding
interest. His knowledge of cloud
formations and atmospheric conditions
stemmed from the time he spent working
in his father's windmill as an apprentice.
When living in Hampstead, he also
devoted much time to studying clouds, or
'skying'.

Constable's year was composed of
sketching in pencil and oil during the
summer months, often at Bergholt until
1817. He then worked these sketches into
major paintings during winter and spring at
his studio in London ready for the Royal
Academy Summer Exhibition.

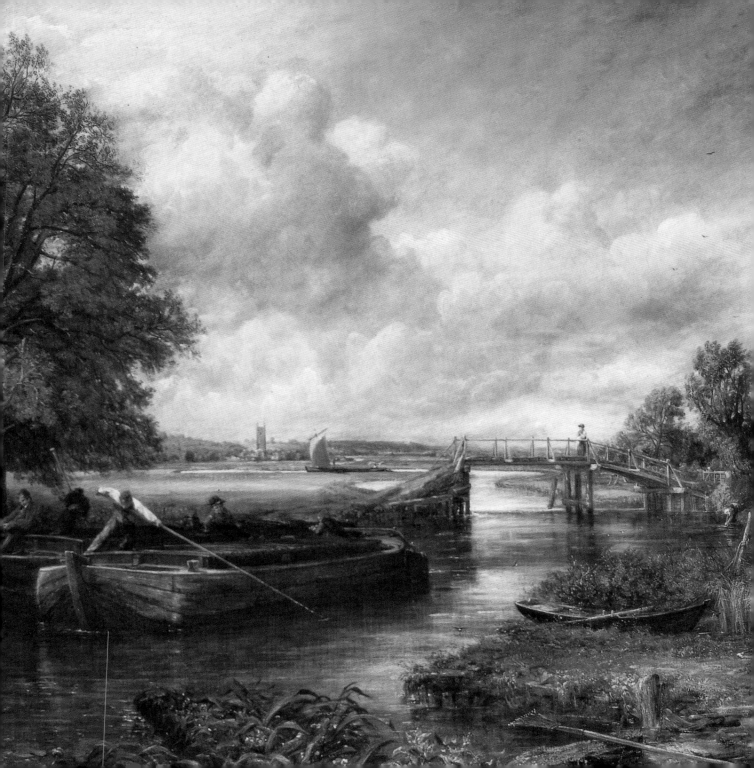

3 *The Hay-Wain,* 1820–1 (detail)
(National Gallery, London)

Willy Lott's House today

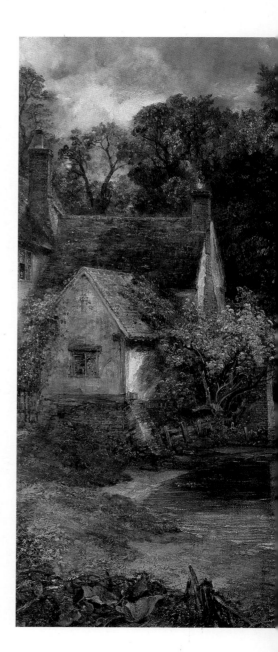

Constable exhibited this painting as *Landscape: Noon,* an apt title considering his fascination with light. He had to stop sketching at noon each day when he would be looking directly into the sun. This painting was his third six-foot canvas and is his best known. It depicts a hay cart, or wain, returning to the fields across the river via the 'flat' ford for another load of hay. A full cart in the distance is about to make the return trip. Constable was insistent on capturing the detail of the scene. Twelve people are busy in this picture going about their daily work.

The two horizontally opposed diagonals lead the eye over to the right, to the haymakers in their white smocks, and across to the mill pool and cottage. At the centre stands the hay-wain, with red harnesses on the horses, a ploy Constable often used to provide a natural contrast to the browns and greens of the countryside.

Whilst painting this picture in his London studio during the winter of 1820–1, Constable found himself short of information about the cart. He wrote to his younger brother, Abram, now the miller at Flatford, to ask John Dunthorne, his childhood painting friend, to make 'outlines of a Scrave or harvest Wagon'. Abram reported that Dunthorne 'had a very cold job'; a good reason why Constable did his sketching in summer!

The building on the left is Willy Lott's House. Willy Lott was the local farmer who spent only four nights away from the house in his 80-year life.

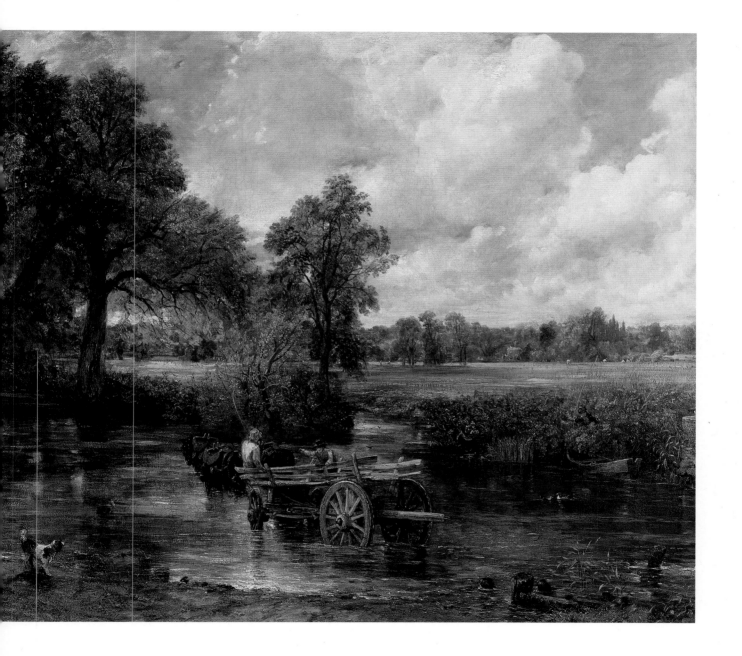

4 *Flatford Mill ('Scene on a Navigable River'), 1816–17* (detail)
(Tate Gallery, London)

Constable was working on this scene in August and September 1816, and it depicts an everyday occurrence on the River Stour, in a calm summer's light. It is just before noon – the favourite time for his major works. The barges are being poled against the current to go under Flatford Bridge, whilst the boy on the horse and his companion have just disconnected the towrope. The picture is composed of a huge amount of activity, so once again Constable keeps the scene under control by the use of diagonals. The sluice on the right echoes the bargee's pole on the other side and forms a contrasting diagonal to the river leading away from the end of the bridge and mooring post toward the Mill and trees.

On the far right a haymaker is cutting a field. This is consistent with Constable's comments that it was a very wet summer,

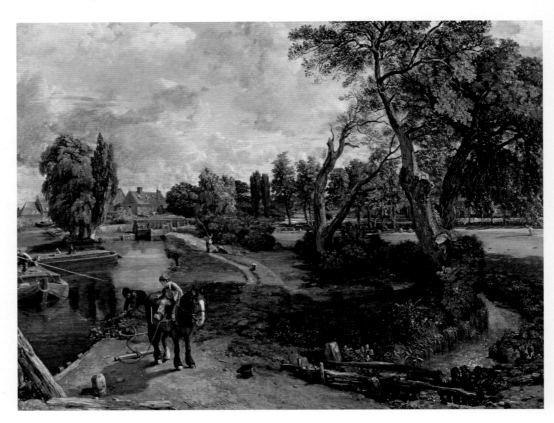

and hay-making had been delayed. Indeed it also delayed Constable, who was anxious to finish the picture so that he could get married. He had known Maria Bicknell most of his life, since she frequently visited her grandfather, Dr Rhudde, the forbidding rector of East Bergholt. Their courtship, which began in 1809, had been difficult, as Dr Rhudde had forbidden Maria to marry a poor painter. It was only the inheritance Constable received on his father's death in May 1816 which enabled him to gain Maria's hand in marriage.

He wrote to Maria: 'I am in the midst of a large picture here – it would have made my mind easier had it been forwarder – I cannot help it – we must not expect to have all our wishes complete.' They eventually married on 2 October 1816 at St Martin-in-the-Fields, London.

This painting appears not to have been preceded by an oil study, but there are numerous drawings and oil sketches which he incorporated into it. The only actual preparatory composition is a pencil tracing which is squared for transfer to canvas.

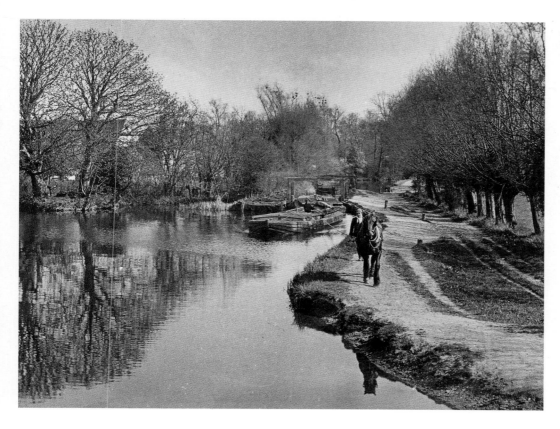

Horses were still towing barges along the Stour when this photograph was taken about 1905

5 *Boys Fishing ('A Lock on the Stour')*, ?1812

(Anglesey Abbey, the Fairhaven Collection / The National Trust)

This was the second of Constable's canal scenes around Flatford, after *Flatford Mill from the Lock*, exhibited the previous year (see p.16), and was also the second-largest canvas he had painted to date. The view this time is in the opposite direction

The concrete-sided lock was built in the 1930s. Constable's turf-sided lock was replaced about 1840

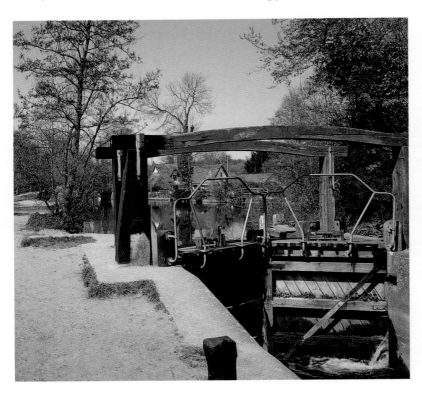

toward Flatford Bridge. Constable appears to have felt the need to approach the task in a new way by making large, detailed drawings of key areas instead of relying entirely on oil sketches, as he did for *Flatford Mill from the Lock*. This was the first picture he sold to a stranger, the Bond Street bookseller James Carpenter – for 20 guineas and some books.

What is thought to be the original painting of 1813 belongs to the National Trust as part of the Fairhaven Collection at Anglesey Abbey. However, much overpainting (particularly in the foreground and sky) means that it is not entirely as Constable painted it. This has led to its authenticity sometimes being questioned, and accounts for its not currently being on view. Unfortunately, the painting appears to have been scraped down underneath the parts that have been repainted, so that even full cleaning would not lay bare what Constable originally depicted.

Between 1830 and 1832 Constable published a series of 22 mezzotint engravings after a selection of his paintings and oil sketches, which would help a wider audience to view the beauties of the English countryside. Constable and John Lucas collaborated on the project. He was an ideal choice; both had a love of landscape; both had been raised in the countryside (Lucas in Northamptonshire); and Lucas, being twenty years younger, was prepared to work under Constable. *Boys Fishing* featured in part four of *The English Landscape Scenery* (1831). A supplementary series was begun but not published in Constable's lifetime.

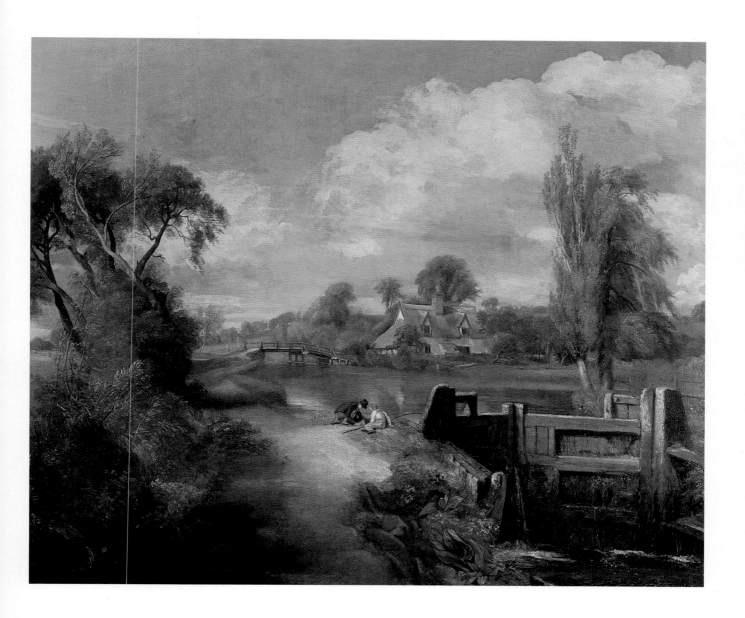

6 *A Boat Passing a Lock*, 1826 (detail)
(Royal Academy, London)

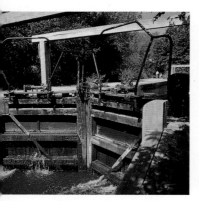

The present lock was restored in 1974 by the River Stour Trust, and the wooden gates and lintels were replaced again in 1991. An automatic gate, which lies on the lock bed in summer, was installed by the Environment Agency in 1990. This is hinged at one end, and rises to form a dam which, with the lock gates pinned back, can be used to control the river levels during winter floods.

The picture shows a boat making its way up the river, tethered to a post, whilst the lock keeper lowers the water level for it to enter the chamber before being lifted to the upper level of the river. In the distance is Dedham church and on the far right Flatford Bridge. This is a variant on an earlier work of 1823–6 in the National Gallery of Victoria in Melbourne.

Constable painted this picture for James Carpenter in 1826 but took it back to work on again and presented it permanently as his diploma piece to the Royal Academy in 1829. When Constable took it back, he came to an agreement with Mr Carpenter, depositing 100 guineas with a banker until he painted another picture of the same size. This episode is typical of Constable's behaviour towards his patrons; he half-regarded their purchases as his own, to be reclaimed, retouched or repossessed at will.

The locks in Constable's day were constructed of wood with tall wooden posts at either end on which the lock gates were hung. A lock lintel across the top prevented the posts being pulled together by the weight of the gates. Constable 'removed' the lintels for artistic reasons. Periodically the wooden revetment holding up the sides of the lock had to be renewed. At some point, the lock depicted by Constable was filled in, and a new lock created alongside in the position it now occupies. This explains why the perspective of some of his paintings of the area looks different today.

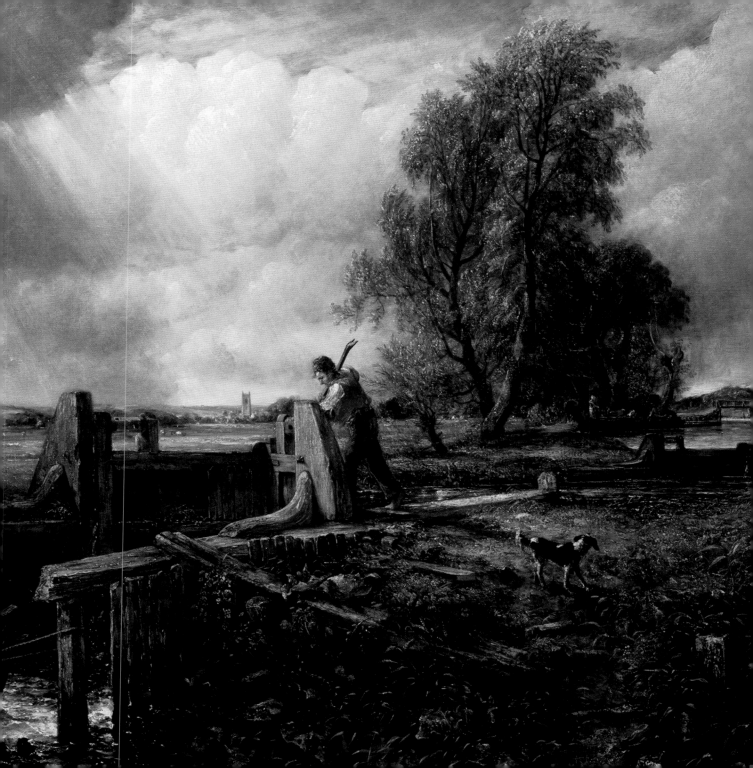

7 *Flatford Mill from the Lock,* ?1811
(detail)(Victoria & Albert Museum, London)

Flatford Mill today

It seems natural that Constable's first 'canal scene' of a coherent group of River Stour paintings should focus on his father's mill. Constable produced at least five oil sketches of the view before settling on the final composition. All show the mill buildings in the middle distance on the left, balanced by the trees on the right. In the foreground, a plane Constable often found difficult to handle, are lock gates and other timbers, and a figure working them. This is the last of the oil sketches, most likely executed in the studio, and brings together elements of the other studies that he had done on the spot. This is typical of how Constable worked. He would often produce preliminary oil sketches in a medium (thinned oil paint) and at a speed which enabled him to capture the light and time of day. Back in his Hampstead studio, he would base his final canvases on these sketches, as well as incorporating details from his pencil sketchbooks. There are reproductions of his small sketchbooks in the Bridge Cottage exhibition.

The oil sketches were working drawings, which were never meant for exhibition, but fortunately many survived. From the mid-19th century, viewers became accustomed to this increasing freedom of expression, which Constable, in part, brought about, and so the oil sketches have become highly regarded in their own right. Indeed many now prefer them to the 'finished' pictures, an attitude that Constable's contemporaries would have found hard to understand.

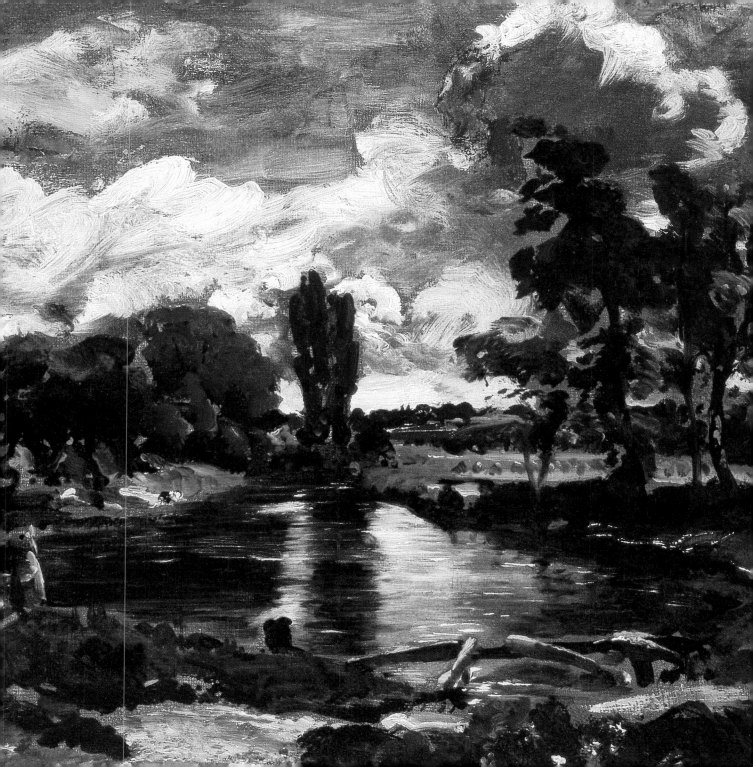

Flatford after Constable

The railways advertised trips to 'Constable Country' from the late 19th century

In 1846, nine years after John Constable's death, the Constable family sold Flatford Mill to John Lott and milling continued until the turn of the 20th century. As a boy in 1898, the painter Sir Alfred Munnings visited Flatford with his father. Looking back to those days, he wrote:

We found it beautiful, unspoilt, as in the days of Constable. The mill was working – no curiosity for sightseers then. There were the locks, the barges, the towpaths and horses. No bottles or food-papers littering the meadows. No sound of car or char-a-banc. Only the sound of the mill, ducks on the stream and breeze in the trees.

The public pilgrimage to Flatford and Constable Country started to develop at the turn of the century, following a

significant number of gifts from the Constable family collection to national museums, and a surge in Constable scholarship. Thomas Cook & Son added 'A Visit to Constable Country' to their list of tours in 1893 to satisfy 'the admiration entertained for the artist by Continental and American visitors'. The Great Eastern Railway also arranged tours to the area with coaches meeting the London trains at Colchester.

However, visitors in the 1920s had fewer expectations. An article in *The Times* reported:

You make your way to the bridge, wondering if you can spot just where he sat to paint the Mill and what changes it will show after all these years, and you come upon a tent marked TEAS AND ICES. You think at last, you have found the true point of view. But doubts arise, and you choose another site. Finally, you give it up in despair, having forgotten what Constable's painting of Flatford Mill looked like and realising too the vegetation has changed.

By the late 1920s Flatford Mill had lost its millstones, and, along with Willy Lott's House, was in a bad state of repair. Thomas Parkington of Ipswich bought the Flatford Mill estate and presented it to the nation on his death as a tribute to the memory of Constable. In 1943 it was acquired by the National Trust and has been leased to the Field Studies Council since 1946.

The National Trust has since acquired more land nearby and now protects over 162 hectares (400 acres) for the nation.

Flatford Mill was presented to the National Trust by Mr and Mrs Parkington

Willy Lott's House in the 1920s

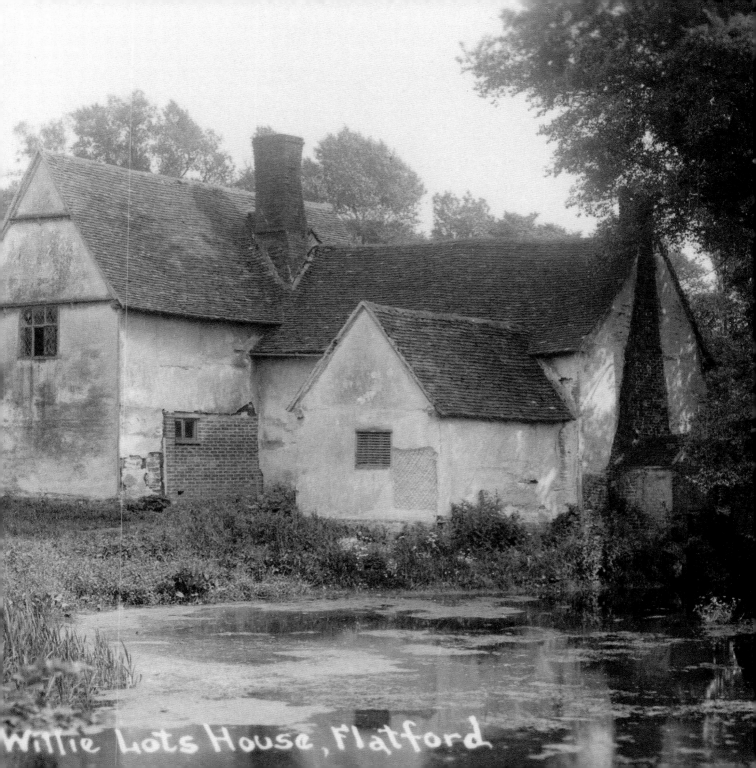

Willie Lots House, Flatford

Other Artists at Flatford

According to the painter Walter Sickert, the Stour Valley had been left 'a sucked orange' by Constable and Gainsborough. However, this is far from the truth, as for the past century it has attracted artists, both famous and not so famous, to explore the beauties of its landscapes. Artists continue to visit Flatford almost every day in the summer months and offer a wide variety of interpretations of the buildings and the landscape.

One of the first artists to be drawn to the area because of Constable was **Thomas Churchyard** (1798–1865). Born in Woodbridge, he attended the same school as Constable, Dedham Grammar School. He was very familiar with Constable's work and owned a number of pictures around the time of Constable's death in 1837. However, there is no evidence that the two ever met. Churchyard's painting of Willy Lott's House is a charming rendition by this amateur artist but has none of the depth of intent that distinguishes the work of Constable, the artist he most admired.

Harry Becker (1865–1928) was another East Anglian artist with Flatford connections. Not a well-known artist, as he hated and shunned the competitiveness of the professional art world, he spent a lifetime recording work on the land just before the advent of mechanised farming. At the turn of the 20th century, Becker may have rented or owned Valley Farm at Flatford.

The most famous painter, other than Constable, associated with the lower Stour Valley, is **Sir Alfred Munnings**

(1878–1959). Munnings lived for much of his later life at Castle House, Dedham (now open to the public as a museum), and was very concerned about changes to the rural landscape in the valley.

When Thomas Parkington acquired the Flatford Mill estate, he intended it to be an art school. This finally happened when the National Trust leased the buildings to the Field Studies Council, which continues to provide art courses to this day. **Eric Ennion** (1900–81), the renowned natural history artist, became the first warden, and later, in the 1950s, the illustrator and painter **John Nash** (1893–1977), who had settled at Wormingford ten miles up the Stour Valley, ran an annual Plant Illustration course. He obtained his specimens from the garden of another artist, **Sir Cedric Morris** (1889–1982), who lived in Hadleigh.

Flatford continues to cast a spell on contemporary artists, with their work featuring in local galleries and on numerous greetings cards.

The Field Studies Centre at Flatford; by John Nash, who ran the Plant Illustration course there in the 1950s and '60s

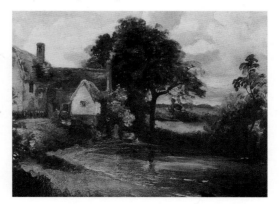

Willy Lott's House after Constable; by Thomas Churchyard (private collection)

The Full River, 1902; by Sir Alfred Munnings (Harris Museum & Art Gallery, Preston)

The National Trust at Flatford

Willy Lott's House being repaired in 1988

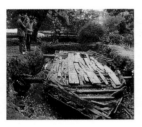

Excavation of the dry dock revealed the remains of a barge very similar to that shown under construction in Constable's 1814–15 painting, illustrated on pp.4–5

(*Right*) Valley Farm

The acquisition of Flatford Mill and Willy Lott's House by the National Trust in 1943 marked the start of its association with the area. The rest of the 20th century saw regular additions of land or property: 1959, Valley Farm and Church Field to the west; 1971, Judas Gap Marsh downstream of Flatford; 1985, Bridge Cottage, the tea gardens and dry dock; 1987, Gibbonsgate Field and lake to the rear of Willy Lott's House; 1995, Millers Field on the hill behind Valley Farm; and 2000, Fen Bridge meadows off Flatford Lane. National Trust ownership safeguards the traditional features of the buildings and landscapes. Over the years there have been numerous threats to the integrity of the site – over-commercialisation, lack of tree management, gravel extraction, over-grazing and loss of hedgerows – which have been countered by National Trust acquisition.

The National Trust is not attempting to 'fossilise' Constable's landscapes. Those tenants who make a living from the land or buildings have to work in a contemporary world. However, the visitors who come to Flatford want to recognise the Constable connections. The work of the National Trust is, therefore, to balance these sometimes conflicting demands.

Perhaps the best-known scene at Flatford is that depicted in *The Hay-Wain*. In 1985 the view beyond the millstream had become completely obscured by tree growth. Tree work by the National Trust has reopened the view across the line of the old ford, giving visitors a better understanding of the distant landscape.

Constable painted the working landscape around him. Many of his paintings are full of activity. Although Flatford Mill is no longer a working mill in its traditional sense, the Field Studies Council provides a modern use, which keeps the hamlet a working place all year round. The Field Centre also offers Trust members and visitors the opportunity to stay in the historic buildings for up to a week at a time.

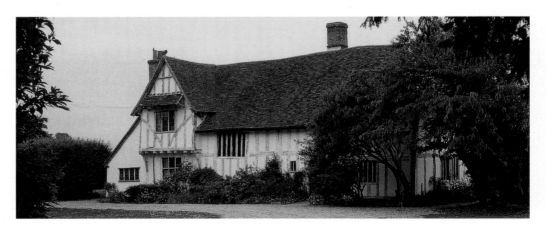

Willy Lott's House today

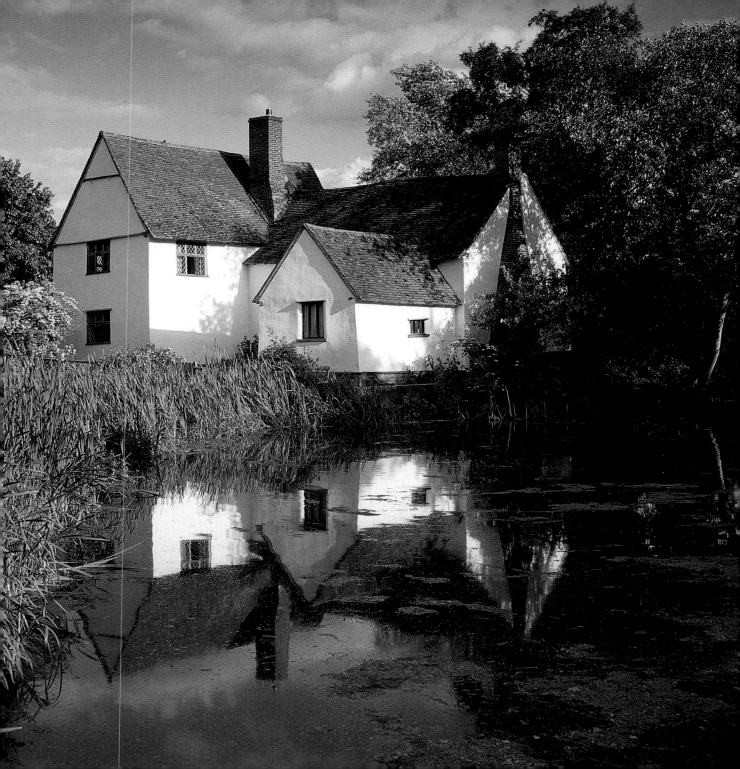

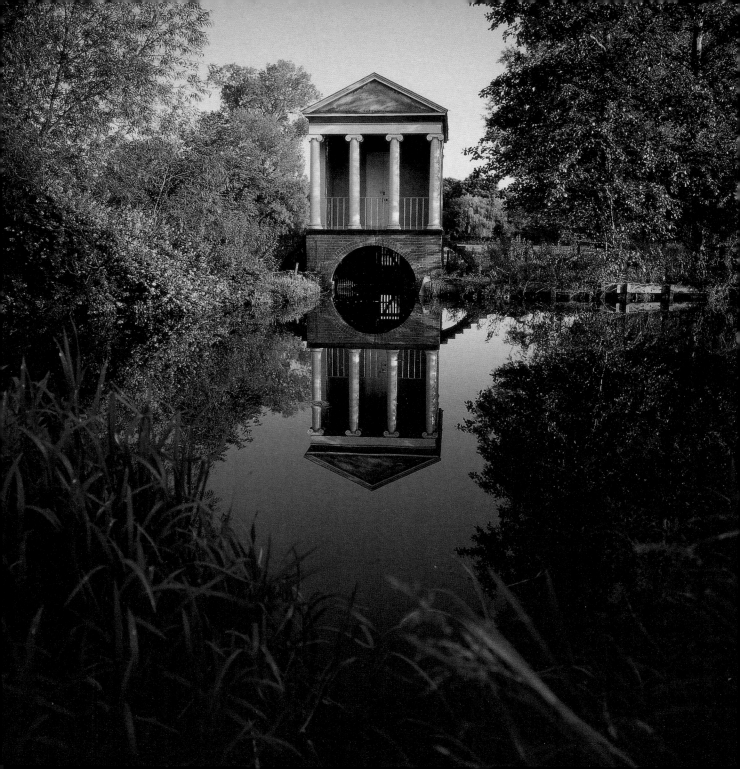

The National Trust in Constable Country

The Dedham Vale, or Constable Country, was perhaps the first geographical area named after an artist. It is not an exact area but extends up the Stour Valley from the estuary at Brantham to roughly Nayland, a distance of about eight miles. The National Trust's main land holding is around Dedham and Flatford, with footpaths affording excellent views of the surrounding countryside.

To the south of the river, the footpath between Flatford and Dedham leads through the valley floor grasslands, which are central to many of Constable's great paintings. These grasslands of Lower Barn Farm and Dedham Hall Farm were acquired by the National Trust in 1992. The large ditch which meanders through the meadows forms the original course of the River Stour, before it was diverted into its present channel to provide water for Flatford Mill. It also marks the county boundary between Essex and Suffolk. The National Trust has been rejuvenating many of the hedges on these farms by coppicing, planting or laying new sections. Modern hybrid poplars have also been removed, as they were intrusive in this historic landscape.

Between Dedham and Stratford St Mary, on the Essex side of the river, lie the National Trust properties of Bridges Farm and Dalethorpe Park. The footpath here forms part of the Essex Way which runs from Harwich to Epping. The farm and park were acquired from the Erith family. Raymond Erith (1904–73) was an architect who worked in traditional styles, drawing his inspiration from the Stour landscape

Sherman's Hall, Dedham, which was bequeathed to the National Trust in 1979 by the architect Marshall Sisson. The main interest is the Georgian façade, and so the property is let and not open to the public

and its buildings; he was also a founder member and President of the Dedham Vale Society. He described the Stour Valley as 'a simple, self-sufficient countryside where for centuries nature has been used but not exploited'.

An example of his work lies on the banks of the Stour at Bridges Farm on the north bank of the river. It was commissioned by his aunt Maud in 1939. A couple of years earlier she had had extensive repairs carried out on her house in Dedham. On finding that the builder who had done the work was in financial difficulty, she commissioned him to build the boathouse to a Raymond Erith design. It includes a changing room, as it was a favourite bathing spot.

The classical boathouse at Bridges Farm was designed by Raymond Erith

The Landscape of Constable Country

Water meadow by the Stour

(*Right*) Dedham from Moorat's Park. The tower of Dedham church appears in many of Constable's Stour valley landscapes, including that illustrated on the front cover

The interplay of trees with the patchwork of grass and arable fields leaves an overall impression of Constable Country as a green and comfortable landscape. It is essentially a summer landscape, the only time of year that Constable painted here. Copses, small plantations of cricket-bat willows, poplars and hedgerow trees, give the illusion of dense tree cover, particularly over the valley sides. This 'enclosure' of the valley leads to a feeling of security, as if the rest of the world is closed off beyond the horizon.

The views across the valley, framed by the trees, embody the real character of the area. The fields by the river are water-meadows, grazed in the summer by cattle. The river, with its flat banks, can be seen from most viewpoints above the valley floor, and forms the spine on which the rest of the landscape hangs. And between the ordered 'naturalness' lie the villages – East Bergholt standing high above the undulating valley side, Dedham nestling below the tree-covered slopes, and Stratford St Mary spread across the valley floor behind the embanked A12.

Perhaps the most dominant and memorable features within the valley are the church towers of Dedham and Stratford St Mary, which can be seen from most positions, and Langham and Stoke-by-Nayland and occasionally East Bergholt. These towers form vertical counterpoints often exploited as focal points by Constable.

Constable himself described the area he loved so much:

It [East Bergholt] is pleasantly situated in the most cultivated part of Suffolk, on a spot which overlooks the fertile valley of the Stour, which river separates that county on the south from Essex. The beauty of the surrounding scenery, its gentle declivities, its luxuriant meadow flats sprinkled with flocks and herds, its well cultivated uplands, its woods and rivers, with numerous scattered villages and churches, farms and picturesque cottages, all impart to this particular spot an amenity and elegance hardly anywhere else to be found; and which has always caused it to be admired by all persons of taste, who have been lovers of painting, and who can feel a pleasure in its pursuit when united with contemplation of Nature.

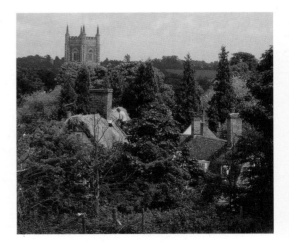

Pollarded willows still grow on the banks of the Stour

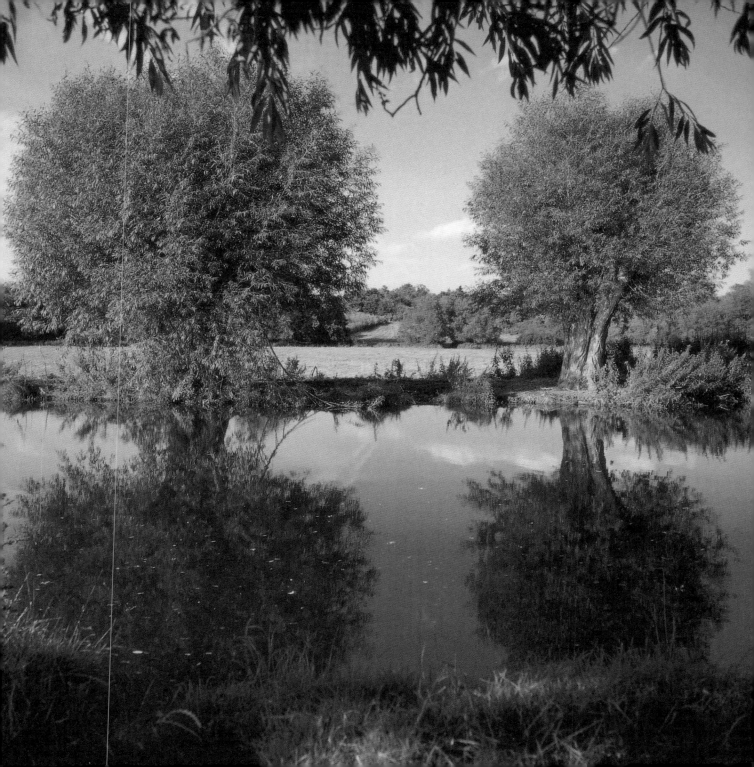

Flora and Fauna

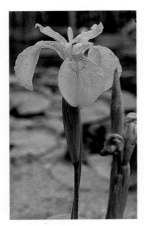

Yellow flag irises grow in the deeper water

(*Opposite*) Cows grazing by the Stour

Elm trees were once the dominant hedgerow tree in Constable Country and often featured in his paintings. Elm is a high-quality timber that will survive indefinitely when immersed in water, and so many of the wooden structures drawn so accurately by Constable would have been made of it.

However, elm caused problems too. It was notorious for dropping branches in summer with no warning, and in the 1920s it threatened Willy Lott's House: 'some of the elm trees had begun to undermine the House with their roots, and the collapse of one of the many elms seen in *The Hay-Wain* nearly destroyed it'.

Many elms died in an outbreak of Dutch Elm Disease in the 1930s, and those which survived or re-grew were killed by a more virulent outbreak in the 1970s. Today very few mature trees survive.

Another tree which has long associations with the area is pollarded willow. At the beginning of the 20th century, men worked for weeks, cutting and trimming the willow to prevent obstruction of the towpath, to make stakes or poles, or splitting them and making sheep-hurdles on the spot. The willows which now line the river between Flatford and Dedham all date from that time. As the trees mature, they offer ideal nest sites for ducks, safe from predators like foxes. They also provide a home for other plants which set seed in the decaying wood at the top of the stunted stem (known as a bolling). Bramble, elder, elm, ash and whitebeam have all been found growing in such places.

The river banks were rich in wildflowers in Constable's day, as can be seen from a number of his paintings and sketches, and the same is still true today. Taller plants grow in deeper water, out of reach of the cows' long tongues (eg yellow flag iris, hemp agrimony and the beautiful flowering rush), whilst shorter plants are found nearer the bank (eg water mint and water forget-me-not). The river is full of fish and large carp can sometimes be seen sunning themselves below Flatford Bridge. Even the occasional eel is spotted swimming upstream. Constable included an eel trap in his painting *The Leaping Horse* (1825; Royal Academy, London), a sight which would have been very common then.

Flatford water meadows

28

The River Stour

Between Flatford and Dedham, the original course of the Stour separates from the navigable section of the river at a point known locally as the 'Float Jump'. Constable depicts this in *The Leaping Horse*, the climax of his six large canal scenes. Although the view is from the Essex bank, looking north, the tower of Dedham church on the right appears in the wrong place. Such topographical licence is not unusual in Constable's exhibition pictures. Working in London, he would have depended heavily on his memories and drawings.

The Stour barge horses had to be trained to jump over three-feet-high barriers erected across the towpath in order to keep the cattle from straying. Unlike a canal with its continuous towpath, the River Stour had been made navigable only after an Act of Parliament in 1705. The navigation company had to negotiate access rights for towing horses from individual landowners, some of whom proved more difficult than others, and as a result, the towpath crossed from one side of the river to the other. Instead of building expensive bridges, the horses jumped on to a platform on the front of the barge, which was then poled across. *The White Horse* (Frick Collection) depicts this activity.

In 1780 Constable's father, Golding, became one of the Navigation's Commissioners. He used the river constantly to deliver flour and import grindstones for his mills, and many other businesses relied on the Navigation for transport: bricks from the Sudbury brickfields were carried all the way to London, and the 'night soil' (a polite Victorian term for sewage) was brought back, to be used as fertiliser on the land. The Navigation was vital until the coming of the railway. After that, although a steam barge was used, the Navigation was never a serious commercial rival, and the last barge navigated its full length around the time of the First World War.

A Stour barge in the early 20th century

(*Opposite*) *The White Horse*, 1819 (Frick Collection, New York)

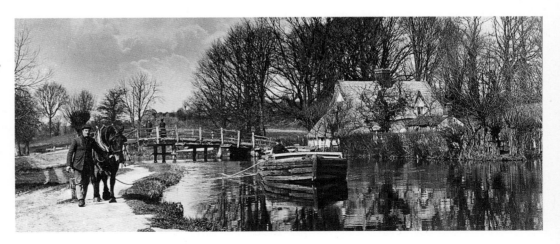

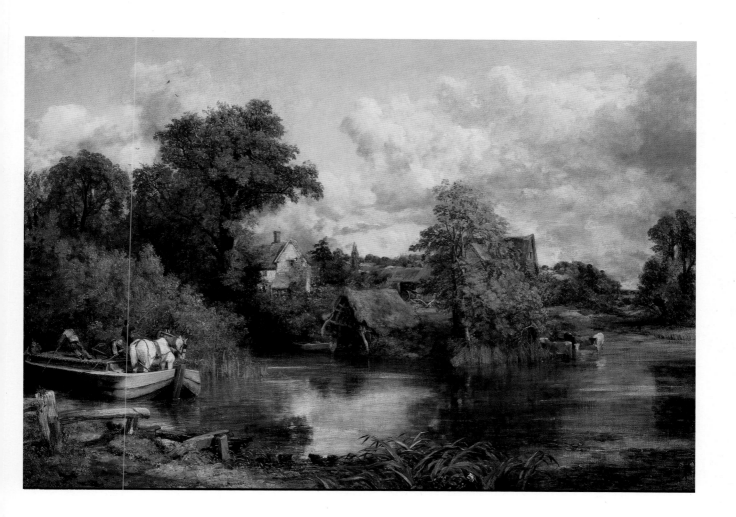

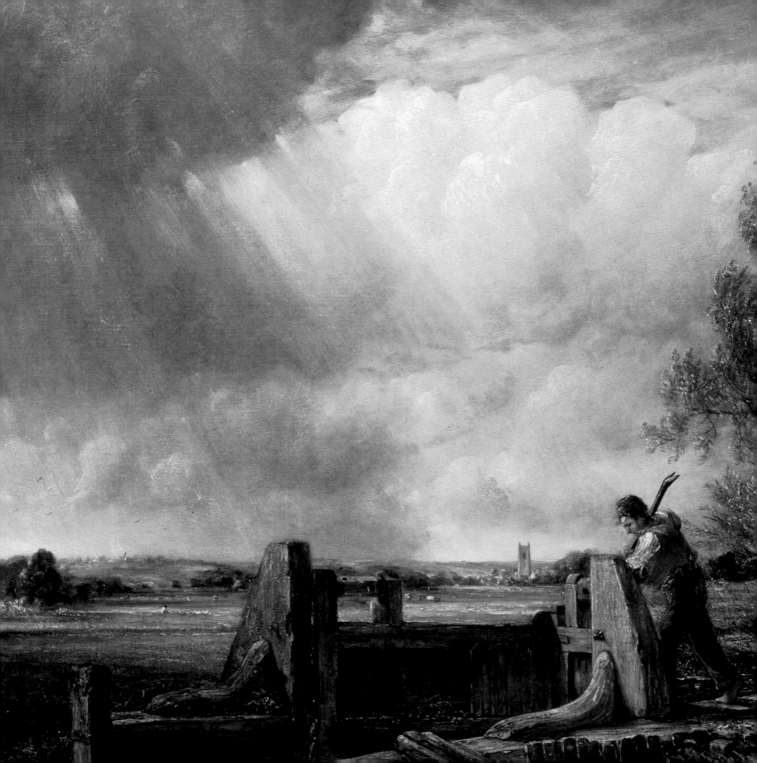